PAOLOZZI portraits

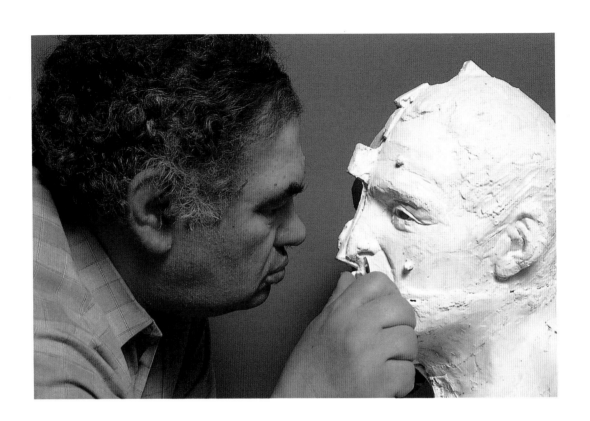

PAOLOZZI portraits

WITH AN ESSAY BY ROBIN SPENCER

Sponsored by London and Paris Property Group

NATIONAL PORTRAIT GALLERY PUBLICATIONS
NATIONAL PORTRAIT GALLERY, LONDON

Published for the exhibition held from 13 May to 7 August 1988

Exhibition organizers: Robin Gibson and Honor Clerk
Exhibition designer: Caroline Brown

Photographs © Frank Thurston unless otherwise stated
Introduction © Robin Spencer, 1988
Foreword © National Portrait Gallery, 1988
Works © Eduardo Paolozzi

Published by National Portrait Gallery Publications, the National Portrait Gallery,
St Martin's Place, London WC2H 0HE

British Library Cataloguing in Publication Data

Paolozzi, Eduardo, *1924–*
Paolozzi portraits.
1. Scottish sculptures. Paolozzi, Eduardo, 1924–. Catalogues, indexes
I. Title II. Gibson, Robin III. National Portrait Gallery
730′.92′4

ISBN 0 904017 87 7

Catalogue edited by Gillian Forrester
Designed by Tamar Burchill
Printed by The Hillingdon Press

PHOTOGRAPHIC ACKNOWLEDGEMENTS

All photographs of Eduardo Paolozzi's works are by Frank Thurston.

The exhibition organizers would like to thank the following for supplying additional photographs:

Arts Council of Great Britain (p. 9, top); Burrell Collection, Glasgow (p. 18, bottom);
Marlborough Fine Art, London (p. 9, bottom); Robin Spencer (p. 13, middle); Tate Gallery, London (pp. 19, top, 18, top).
Rosalie Cass of the South Bank Centre supplied the photographs of Auguste Rodin's
works on p. 10 (Ph 323, photo C. Bodmer, © Musée Rodin and Bruno Jarret)
and p. 17 (Ph 384, photographer unknown, © Musée Rodin by SPADEM). The
Musée Rodin supplied the photograph on p. 19, bottom (S1197, photo Bruno Jarret, © Musée
Rodin and Bruno Jarret).

Cover credit: Shelves in Eduardo Paolozzi's studio. Photograph © Frank Thurston

CONTENTS

FOREWORD

'Emma Guy Bertolucci', 'Greta Gablik', 'Eldorado Zed Frayling' – just some of the names bestowed by Eduardo Paolozzi on the reorganised features of the famous and the clichéd in his postcard *Heads of Heroes* included in this exhibition. The names themselves are an indication of the ambiguous and nearly always sardonic attitude Paolozzi has brought to his representations of human physiognomy. Like the more serious sculptured heads which also began to appear in 1984 (*Portrait of an Actor (for Luis Buñuel)* and *Yukio Mishima*), these icons of reconstructed features are drawn from his immense store of imagery, represented symbolically in the exhibition by the three shelves of fragments and maquettes. The layers of reconstructed and reorganised motifs, whether in collage or sculptural form, force the viewer to reconsider the whole notion of recognisable likeness and the vulnerability of human individuality.

In his excellent essay specially written for this catalogue, Robin Spencer traces the development of portraiture in Paolozzi's work from the influence of Surrealism and Max Ernst in the collages of the late 1940s through to the Cubism of the 'cut' heads and figures of the current work. Unlike Cubism, however, where the reconstruction of the surface is at a basic level a purely formal concern, Paolozzi's reconstruction of both two- and three-dimensional surfaces carries a weight of symbolic associations and meaning not normally associated with conventional portraiture. It was not until the self-portraits of 1987 culminating in the massive bronze of *The Artist as Hephaestus* that it became evident that Paolozzi was interested in the notion of an individual likeness.

Paolozzi's exploration of the possibilities of the self-portrait began coincidentally at about the same time as the commission from the National Portrait Gallery for a portrait of the architect, Richard Rogers. There had originally been no special significance in the choice of subject for the commission beyond Richard Rogers's outstanding eminence as an architect. Its appositeness soon became obvious, however. Both sculptor and architect had Italian parents; they had previously worked together on the project for the ill-fated National Gallery extension; and was it not possible to see in Rogers's great buildings such as the Pompidou Centre in Paris and the Lloyds building in London an echo on a large scale of some of Paolozzi's sculpture of the 1960s? Commissioned portraits are always open to innumerable problems and the outcome sometimes very much a matter of chance. For once, the ingredients seemed to be just right.

When two of Paolozzi's self-portraits were exhibited at the Royal Academy in 1987, it could be seen that, although whole-length figures, they were created in a similar way to his earlier portrait heads, by a process of reorganisation of given elements, although the symbolism was more traditionally externalised by additional titles ('Vulcan', 'Hephaestus') and by extraneous objects (the 'Strange Machine'). Witnessing the creation of the portraits of Richard Rogers from two realistic, neo-classical and rather Messerschmidt-like busts, it was clear that in both the self-portraits and the Rogers portraits the first likeness was

merely the preliminary step in a complex creative operation. Deconstruction of, in this case, images created rather than received by the sculptor, might seem an arbitrary and self-defeating device for purely stylistic reasons. The process of cutting-up and reconstruction of elements in the Rogers busts, and their transformation into expressive and weighty images loaded with symbol and meaning however showed how for the sculptor, mere observation and the re-creation of a likeness were almost mechanical operations in the evolution of a work of art with far wider and more profound implications than the original image. In the case of the Rogers, the creation of the two busts ran parallel to Paolozzi's preoccupation with Blake's print of Newton, both for its formal and symbolic relevance (discussed by Robin Spencer). Finally, the received image of Newton was united with the created image of Richard Rogers in a third highly symbolic and totally original work. The creative process was complete.

At the time of writing, the three Rogers portraits have yet to be cast. The Gallery is, however, proud to have been associated with the creation and acquisition for the collection of what promises to be some of the most important portrait sculpture of this century.

ACKNOWLEDGEMENTS

Our primary debt is to Eduardo Paolozzi who, with his assistant, Marlee Robinson, patiently collaborated on all aspects of this exhibition and supplied most of the loans. Marlee also undertook to organise the majority of the illustrations for the catalogue and we are grateful too to Frank Thurston for taking most of the photographs.

Without Richard Rogers's generous agreement to sit to Eduardo, there might have been no exhibition and the Gallery is indebted to him for his co-operation on the project. We must also thank Robin Spencer for his illuminating essay, Tamar Burchill for her elegant design of the catalogue and poster, and Caroline Brown for her sympathetic setting for the exhibition. I am also grateful to my colleagues Gillian Forrester, Carole Patey, Sarah Kemp and Honor Clerk for all their help and support. Barbara Grigor originally suggested a Paolozzi exhibition to us and to her and Murray Grigor we are also indebted for the use of their excellent film *E.P. Sculptor* during the exhibition.

That we are able at all to produce such a splendid catalogue is entirely due to the generosity of The London and Paris Property Group who have financed its production. Following on their commission of a major Paolozzi sculpture for their new building at 34-36 High Holborn, this amounts to a far-sighted and all too rare act of private patronage. The Gallery is most grateful to Peter Davidson and London and Paris for the continuation of this enlightened policy.

ROBIN GIBSON

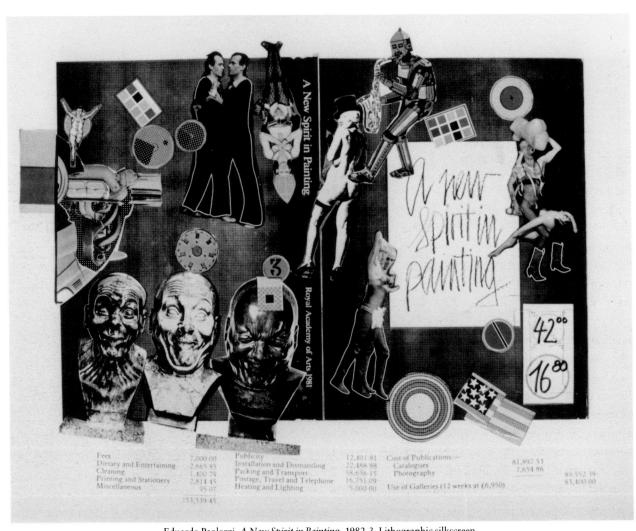

Eduardo Paolozzi, *A New Spirit in Painting*, 1982-3. Lithographic silkscreen.

PAOLOZZI as a portrait sculptor

ROBIN SPENCER

*The highest praise I can possibly give to Paolozzi is to
say that if the entire 20th century were to vanish in some
huge calamity, it would be possible to reconstitute a
large part of it from his sculpture and screenprints.*

J.G. Ballard[1]

The art of the portrait outlives Narcissus. In the touring exhibition *Lost Magic Kingdoms* which he selected from the Museum of Mankind, Paolozzi demonstrates through ethnology rather than art history, the endless variations to be made on the human form within cultures other than our own.[2] The century-old assimilation of so-called 'primitive' art expanded the possibilities for Western artists, as it did for the twenty-one-year-old Paolozzi one day in Oxford in 1945 when he drew African heads in the Pitt Rivers Museum. In the same year he visited the Ashmolean Museum to draw heads after Rembrandt. In the nineteenth century, similar student exercises would have been done as copies, either to facilitate technical skill, or to discover the secrets of the ancients and the old masters. One hundred years ago Whistler asked of the artist 'in portrait painting to put on canvas something more than the face the model wears for that one day, to paint the man, in short, as well as his features.'[3] In acknowledging the relentless voyeurism of the camera to document aspects of life hitherto unrecorded by the painter, the artists of Whistler's generation, particularly Degas, brought the art of the past into new configurations with the present, by showing not only man but the complexity of the modern world in which he lived. Thus arose the imagery of 'modern life', with all the poetic sensibilities which Baudelaire endowed it, and the social awareness that Walter Benjamin brought to enhance it. Rodin also recognised that photography could modify the perception of flesh and muscle. He used it as a means of editing his work in progress, and of judging the pictorial effect of his sculpture. For about a century the potential of photography to multiply reproduced images of art, rather than render a human likeness, has influenced the way painting and sculpture is made. It is perhaps because of, rather than in spite of, a failure to establish a common language of expression that the art of the portrait has survived so long into the twentieth century.

It is difficult to think of two styles more formally and ideologically opposed than neo-classicism and expressionism. Paradoxically, these stylistic polarities now provide a rich source of diversity for art. Within the

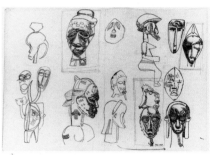

Eduardo Paolozzi, *Drawings of African Sculpture*, 1945. Arts Council of Great Britain.

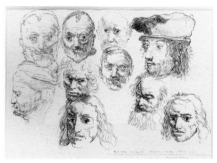

Eduardo Paolozzi, *Drawings after Rembrandt*, 1945. Private Collection.

work of individual artists the two styles can co-exist, as if to impose a discipline on the extremist expression for which they have historically been held responsible. Consider, in Britain alone, the work of Bacon, Freud and Paolozzi. All three work in a figurative tradition marked by strongly personalised expression, however different might be their means. Freud finishes a portrait, we are told, with the face; Paolozzi often begins one with a postcard. Most of Freud's work is done with the sitter in the room; Paolozzi's only starts when the sitter leaves it. Of neither Bacon, Freud nor Paolozzi can it be said that anything approaching a conventional likeness results. If their object were to achieve it we need only compare flesh with paint and clay, and marvel at the differences. Nevertheless, since Rodin, modern sculpture has been searching for a new metaphor for flesh. For the twentieth-century artist still working in the shadow of Picasso's Cubism, portrait sculpture has remained especially problematical. The mixed reception of Epstein's portrait busts by modernist critics bears witness to this. Recently, Paolozzi has begun to make sculpture which specifically alludes to the tradition of symbolic portraiture, although the methods he uses are consistently adapted from his previous sculptural practice. To do so he has re-examined the language of sculpture in relation to the classical heritage absorbed by Rodin; as well as the implication of its legacy for artistic expression in a post-modern age.

■ ■ ■

The sculptor models a metaphorical self-portrait in the imagined guise of Hephaestus, the Greek god of fire, son of Zeus, and maker of elaborate works in gold, silver and bronze (see *Self-portraits*). The pose is awkward as befits the lame god, standing one foot in front of the other like an ancient Greek *Kouros*. In literature the image of the sun as a round disk is a descendant of the marvellous five-layered shield of Achilles whose fabrication is the great deed of Hephaestus in the *Iliad*, and which in Paolozzi's figure is shown clasped as a strange surrealist machine. This votive gesture is somewhat ambiguous, an uncertainty accentuated by the forward-bending posture of the muscular, sometimes comic god, who is reminiscent of Jean d'Aire who holds the keys to the city in Rodin's *Burghers of Calais*. All wonderful life-enhancing works came to be attributed to the divine smith Hephaestus, including metal figures that moved and almost equalled living beings. Homer also has Hephaestus making, for the house he constructed in imperishable bronze, a 'set of twenty three-legged tables to stand round the walls of his well-built hall. He had fitted golden wheels to all their legs so that they could run by themselves to a meeting of the gods and amaze the company by running home again'.[4] Hephaestus's magic shield protects Achilles in battle after battle, but is ultimately powerless in saving him from the over-bearing pride of his mortal self. Exposing his vulnerable heel to Paris's arrow

Auguste Rodin, *Jean d'Aire, nude study*, 1886.
25 x 19 cm. Musée Rodin, Paris.

Achilles dies, which marks him out from the gods, and underlines, in universal metaphor, the tragic failing of the human condition and man's inability to make good use of gifts given to him by the gods.

The image of Hephaestus or Vulcan, his Roman equivalent, is an appropriately poetic one, not just because it evokes in its form and iconography the robotic subject-matter of his past creations, but because it also voices the serious concern Paolozzi has expressed for a society which increasingly downgrades the imagination by favouring material values over spiritual ones. Now that the social consensus has been skilfully manipulated to favour the cause of the strong over that of the weak, the confrontational barriers between art and society which were erected by the original Surrealists have long been dismantled; hence many of today's younger artists are reduced to pursuing an endlessly fleeting avant garde which is referential to nothing but itself. Throughout his career Paolozzi has made many such references in his art, and more recently in his writing to this state of affairs; to political power and capitalist corruption, war and militarism, ecological issues and the venery of the art market. They have gone by almost completely undiscussed. Most art critics prefer to omit mentioning such issues, particularly when they touch on the art world; they feel more comfortable reserving language for what they think are exclusively 'artistic' concerns. With the gradual decline of abstraction as a force in the West, writers on art are beginning to address themselves to these questions and adapt a more analytical response to artists whose work reflects the imagery of twentieth-century experience. For these reasons Paolozzi is reluctant to have his early work merely reduced to the category of 'Pop Art', or be considered a post-modernist; instead he prefers to be known as an unfashionable Surrealist.

Only a very few years have passed in which he has not made a head, whether animal or human, the subject of these obsessions, for collage, drawing or sculpture. Either liberated with scissors from an unfamiliar context to make prints, or modelled in clay, cast, cut up and reassembled to make sculpture, the endless permutations of his subjects and styles – man and machine, ancient and modern, European and 'primitive' – have resulted in new ways of seeing and making art appropriate to the Western world which is rich in multiplying the imagery of easy pleasures, but poor in finding practical solutions to diminishing social resources. The undervalued and ephemeral artefacts from the real world which so often appear in Paolozzi's work, the syntax of his art, can be likened to Picasso's *papiers collées* or Schwitters' bus tickets. Already, his rephrasing of this syntax has been re-translated into junk sculpture and disposable classicism by the New Sculptors and post-moderns of a younger generation. Materially and conceptually ephemera offers the same creative potential today, but as well as most laymen many artists still regard it as worthless and to be quickly discarded. In proliferating so readily it threatens to

overwhelm and numb the imagination, but it also carries the psychic health warning for an essentially uncreative and uncaring society. This is the Ecology of Waste which Paolozzi never tires of emphasising by encouraging, in the way he makes art, a fresh revaluation of the past by bringing it into new relationships with the present, both from our own experience and from that of less familiar cultures. It was to show that the 'poorer' cultures of Africa and the Sub-continent can produce, using reduced and slender means, tools and objects of greater beauty and sophistication than our own that he chose two hundred items from the Museum of Mankind for the exhibition *Lost Magic Kingdoms*. The exhibition is important, not only because it demonstrates Paolozzi's life-long interest in 'primitive' art and society, but because it attempts a redefinition of artistic 'value' and emphasises that the *process of making art* has more importance as a *social solution* than creating it as a means of *social improvement*. In *Lost Magic Kingdoms* he offers several suggestions as to what the role of the artist in society might be. He believes this is a concern that should be addressed by today's artists.

For more than forty years portraiture has regularly been the medium and subject of these concerns, rather than merely the object of his art, a means rather than an end. Paolozzi's portraits, like Picasso's and those of the Futurists and Surrealists to which his art rightly lays claim, have initially less to do with the likeness of flesh than with the likeness of art; or the *unlikeness* of art, for true art inevitably seems unfamiliar when originally forged from the heritage of the safe past and uncomfortable present. Like his earliest collages, whether in paper or clay, the portraits and heads combine the familiar icon with the unfamiliar, and refashion man in a new relationship with his environment. In this sense all the portraits he has made are self-portraits. But the machine-man, man-machine relationship offers a clue to the way he humanises his subjects, just as the frog, the horse and the dog which he has also made in sculpture, can have their animality intensified or reduced in relation to the man-made world in which they have their being.

Time and the history of things play an unseen but essential part in Paolozzi's creative process, as they did for the Surrealists. The classic image of an umbrella with a sowing machine on a dissecting room table is poetic not solely because of the incongruity of the juxtaposition, but because the social and temporal function of the three objects has been subverted and unexpectedly redirected. Paolozzi has a strong empathy for George Kubler's book *The Shape of Time*. At a recent lecture, in reply to a question about his method, he gave this answer: 'I cannot look at anything without thinking of its history – whether a broken umbrella or an old piece of wood on a skip – to the point that I forget what I am doing.' Similarly, when working on a large public scale, such as the mosaics for Tottenham Court Road underground station, the past, present and future of the passer-by

Eduardo Paolozzi, *Blueprint for a New Museum*, 1980-1. Screenprint.

had also to be considered. It was 'to counteract and perhaps contradict our tendency to isolate phenomena and impose a separateness of the object' and to 'provide a new culture in which problems give way to capabilities'[5] that in 1980-1 he made a series of prints on the theme of *Blueprint for a New Museum* which show a judicious selection from the history of things. In time they span antiquity to the present and range over the history of art and technology; and include a bicycle, a space lab, a B52 bomber and a cast of the Laocoon which Paolozzi sees as a universal metaphor to be used as an image in the year 2000, compared with the B52 which in technological terms is, paradoxically, already an obsolete antique. Housed in the Gothic space of Cologne Cathedral the objects are superimposed against a background consisting of a structural section from the Beaubourg building in Paris, designed by the architect Richard Rogers who is the subject of one of the portrait sculptures in the present exhibition (see *Portraits of Richard Rogers*).

Ever since Lessing wrote about the Laocoon the sculpture has remained a powerful influence on the formal and physiognomic expression of Western art. In the past it has served Paolozzi for both figurative sculpture and prints, and it continues to exercise a powerful fascination for him. This has been reinforced by the ancient Greek sculpture in the Glyptothek, Munich, where he has been Professor of Sculpture since 1981. 'All the gods and heroes with their broken limbs and mutilated faces convey their own experience of time, which I find very moving.'[6] To emphasise the continuity of his obsessions he has described his recent sculpture as showing 'previous work pressing through'.[7] In the early collages reminiscent of Max Ernst, such as *Head of Zeus* (no. 9) and *Self-Portrait* (no. 10) of 1947, classical sculpture from the Parthenon is obscured and all but displaced by radio valves and machinery from a now vanished technology. For other collages, also made during the winter of 1946-7 before he left for Paris the following summer, Paolozzi pasted similar modern images over plates from Alfred Toft's student manual *Modelling and Sculpture* (1929). In cutting the collages in this way Paolozzi made a direct reference to the process of producing sculpture, which in 1946 he had only just begun to make. He thus links the two media – sculpture and graphic art – in a manner which was to be prophetic for his future. While images and references to ancient as well as 'primitive' art appear and reappear throughout his career, in the last seven years antiquity has literally 'pressed through' from the background to occupy a foreground position.

By rearranging the features of prominent personalities from the covers of recent *Time* magazines in 1952 Paolozzi made an ironic and punning comment on the fugitive temporality of people in power. This surrealist principle of dissection and reassembly, which underpins the *Time* heads, also informs the first machine head of 1950, *Mr Cruikshank* (no. 2). The sculpture is based on a sectionalised wooden model made by the

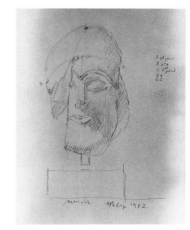

Eduardo Paolozzi, *Warrior's head*, 1982. Pencil on paper.

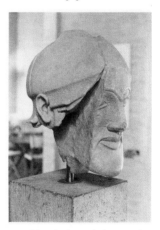

Greek head, Glyptothek, Munich.

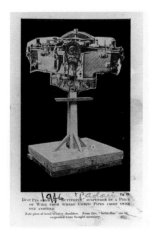

Eduardo Paolozzi, *Butterfly*, 1946. Collage.

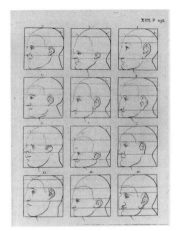

Heads after Dürer, from Lavater, *Essai sur la Physiognomie*, 1753.

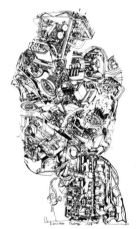

Eduardo Paolozzi, *Automobile Head*, 1954. Screenprint.

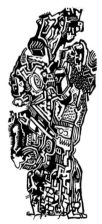

Eduardo Paolozzi, *Head I*, 1984. Woodcut.

Massachusetts Institute of Technology to measure irradiation of the human skull. The conception of the sculpture is unique in his work for two reasons. It is the first sculpture he made to take as its subject a ready-made machine. Secondly, and more important, while he has always been keen to emphasise the general idea of collage for both his sculpture and prints, *Mr Cruikshank* was the very first sculpture to be based on the principle of the cut which he had already used for his collages in 1946-7. (The plaster version of the head takes apart geometrically like the wooden model on which it is based; the sections are clearly visible in the bronze cast.) While in Paris Paolozzi had been impressed by the sculpture of Giacometti who was then making his famous series of elongated heads and bodies, using the simplest hand technique of modelling clay with a penknife. He was as much impressed with Giacometti's methods as with the end results; for clay and plaster still remain his basic raw materials as a sculptor. Remarkable though Giacometti's images are, they were still made in the centuries-old way of modelling, by adding and subtracting clay, and by carving plaster. Paolozzi's most significant and innovative contribution to sculpture in the twentieth century has been to enlarge the critical debate between modelling and carving (which played so formative a role in the creation of modern sculpture in Britain in the 1920s and 1930s) by introducing a third alternative – the cut – thus opening up further possibilities for the development of sculptural language. It was this principle which Paolozzi developed in the 1950s with his lost-wax process bronzes cast from cut plaster sections embedded with machine parts and technological detritus. In the 1960s his figurative pieces were assembled using pre-fabricated aluminium components; and in the 1970s the wood and plaster reliefs relied for their construction almost entirely on the handsaw and the stanley knife. But it is with a return to the figurative sculpture in the 1980s that the evidence of the cut is again most apparent.

The recent portrait heads enlarge a vocabulary which was first given sculptural expression over thirty years ago. The machine parts which were collaged to make the 1954 screenprint *Automobile Head* became synthesised in the late 1970s with echoes from African sculpture to make etchings and woodcuts which are the immediate graphic forerunners of the present portrait heads. The collage *Automobile Head*, with its interplay of mechanical and human forms – engine 'brain' and crankshaft 'spine' – has always been a seminal image. It has been regularly reprinted, most recently in 1980. In the heads and figures of the 1950s the same nuts and bolts of junk technology were used to encrust the surface of the sculpture. Two years after Paolozzi gave his *Bunk* lecture of popular imagery to the Independent Group in 1953, the ICA mounted an exhibition called *Wonder and Horror of the Human Head* which examined the symbolism of the head in mythology, pre-history and art. It included works and reproductions by Archimboldo, Dürer, Klee, Brancusi, Ernst and

Magritte; and was divided into sections with titles such as 'Head as Creative Force', 'Geometric Form', 'Expression', 'Metamorphosis', 'Monsters and Grotesques', 'Gods, Saints and Heroes'. The exhibition theme also extended to a section devoted to reproductions of the head in popular art and advertising, thus making a bridge with the nascent 'Pop Art' movement in British art as well as the preoccupations of painters such as Francis Bacon, who at this time was also investigating the expressive potential of the head both in art and the mass media.

The 'primitive' motive for making human images as fetishes to repel unwanted spirits or welcome benign ones has a similar function in Western culture which is reflected in the portrait heads. Paolozzi has suggested that life lived in major cities around the world is also 'primitive, highly ritualistic and incredibly unsophisticated. One is surrounded by people in city uniforms spending their lives pushing buttons with the sole aim of earning money. How "primitive"!'[8] Regular contact with the ethnographic collections in the 1940s then housed in the British Museum, and a renewed interest in the magical properties associated with the art which is now in the Museum of Mankind, has helped to reinforce these ideas. The magical function of the head as the receptacle of the brain 'where we imagine the shape of the elements like the wind and the stars'[9] might be said to have a Western equivalent in the sculpture of Brancusi who represented the head as the seat of creativity, either erect and awake or recumbent and sleeping; a tradition which relates to painting. But for Paolozzi, the paradox of creativity is that it is always preceded or simultaneously accompanied by, an act of destruction, which is both real and symbolic. The very process of collage makes this inevitable. 'The word collage is inadequate as a description because the concept should include "damage, erase, destroy, deface and transform all parts of a metaphor for the creative act itself"'.[10] Thus the creative act of collage is 'a method of taking the world apart and reassembling it in the order that one understands, and that order is ruled by one's emotions, intuition and intellect. That is Surrealism. And that is perception'.[11]

If the technical process of casting, cutting, recasting and reassembly which began with *Mr Cruikshank* in 1950 owes its origins to Surrealism, the resulting power of the portraits reflects older sculptural traditions. Although individual features of the heads are heavily distorted, their basic structure, like that of *Mr Cruikshank*, remains essentially geometric. This is partly accounted for by Paolozzi's interest in the work of the eighteenth-century sculptor Franz Xavier Messerschmidt. It is not the physiognomic eccentricity alone which attracts him to these portraits, but the Viennese sculptor's paradoxical achievement of having produced a seemingly endless series of expressive variations on the severe geometric theme of a neo-classical bust. Based on a formal discipline, Messerschmidt demonstrates that the most extreme forms of human expression are not

Eduardo Paolozzi, *A New Spirit in Painting*, 1982-3. Lithographic silkscreen.

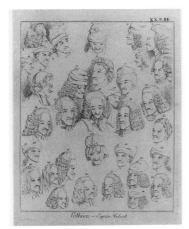

Heads of Voltaire after Hubert, from Lavater,
Essai sur la Physiognomie, 1783.

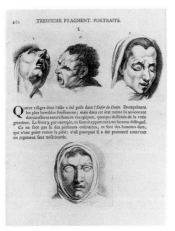

Henry Fuseli, *Heads*, from Lavater, *Essai sur la
Physiognomie*, 1783.

only possible but can also be artistically arresting. Individually, Messerschmidt's busts, like Paolozzi's, carry a limited amount of information; but seen as part of a series each portrait and expression informs the other. While an attempt to show Messerschmidt's sculpture as a literal illustration of physiognomic theory then current is unconvincing, no interpretation is possible unless the whole range of individual expressions are considered together, in the comparative manner of Fuseli and other artists, whose works, ancient and modern, illustrate Lavater's *Essai sur la Physiognomie* of 1783. Paolozzi's art endorses Fuseli's way of defining artistic invention: 'to *invent* is to find: to find something presupposes its existence somewhere, implicitly or explicitly, scattered or in a mass. Form in its widest meaning, the visible universe that envelopes our senses, and its counterpart, the invisible one that agitates our mind with visions bred on sense by fancy are the element and the realm of invention; it discovers, selects, combines the *possible*, the *probable*, the *known*, in a mode that strikes with an air of truth and novelty, at once.'[12] He engages his own art with these traditions in order to reinvigorate the fossilised state of portrait sculpture. By using the Surrealist technique of the cut he is also able to explore expression beyond physiognomy. The heads are portraits of an age, as much as of individuals. For the contradictory forces of destruction and creativity are both the content and form of this art. They are represented by the opposing subjects he chooses for the heads. All have their sense organs enlarged or defaced and realigned. The series began with portraits of the Japanese writer Yukio Mishima, who in ritually destroying his own life attempted to reaffirm a future for Japan independent of Western influence. This metaphor of a culture which transcends personal annihilation is the literal embodiment of the destruction-creation myth. Mishima had been preceded in 1971 by a Western equivalent, President Kennedy, who was represented in the form of a neo-classical bust as a symbol of destructive waste and placed in an aluminium skip with *Mr Cruikshank*, alongside castings of discarded sculpture. In the series of heads in this exhibition the great Surrealist film maker *Luis Buñuel*, debunker of orthodox Catholicism, is given a crucifix (no. 3), whereas a god of fraudulent Christianity *Electric Bishop* (no. 4) is cosmetically streaked with paint and bears the symbol of anti-Christ. The positive creativity of an artist such as *Count Basie* (no. 8) is paired with its essentially destructive opposite *The Critic* (no. 5).

It might be said that the plaster pieces of heads, bodies and limbs, which cover the shelves of Paolozzi's studios in London and Munich (no. 1), resemble hundreds of feet of film waiting to be cut by a film editor; like discarded frames the sculptor's fragments can be used and reused when the right moment presents itself. When that moment arrives, by the same laws of chance which governed Schwitters and the Surrealists, the artist experiences a dynamic commitment which leads him beyond his own

preconceptions and aspirations to something he had not initially believed possible. In the same way, an imaginative writer invents a character with free will who acts independently of his creator, first in a novel and then on the screen, reinterpreted by an actor. In the exhibition a typical shelf includes fragments which relate to work in progress. There are self-portraits in plaster, limbs from the Hephaestus sculpture, hands and feet, relief sculpture and models of neo-classical architecture. Also included is a bust after a portrait of an unknown man, sometimes thought to be an actor, which Van Gogh made in Arles in 1888: a translation from painting to sculpture. The stylistic range which embraces neo-classicism and expressionism is still wide, but the options governing the laws of chance have been distilled and reduced. The moment is approaching when a final commitment must be made. The option of combining naturalism with allegory, the antique and the modern, marble with plaster, was also open to Rodin. Rodin kept in reserve hundreds of arms and legs, hands and feet, in order to try out new combinations for figurative sculpture. Many of them now survive in the Musée Rodin. It was also his practice to have transitional casts made of portraits he was working on so that a spontaneous stage could be preserved for future development.[13]

The facility to by-pass entrenched sculptural convention lends support to theorists who see Rodin as a protomodernist sculptor.

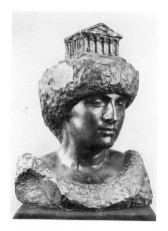

August Rodin, *Pallas Athena with the Parthenon*, 1896. Marble and plaster. Musée Rodin, Paris.

■ ■ ■

Post-modernism has not just meant stylistic liberation, but rather a means of breaking down some of the critical dogmas of modernism which have degenerated into clichés. Critics are now less likely to want to make a futile last-ditch attempt to establish an unbroken line from Cubism to the latest avant garde if it consists of horse manure, rotting margarine or ten tons of newspaper with a piano on top. In an age when 'anything goes', 'One sees in sculpture like that all the paradoxes that freedom brings. Freedom is what individuals bring from their personal culture'.[14] The freedom which Paolozzi chooses to exercise often involves him in investigating past orthodoxies, such as classicism, in order to discover how it was that great artists – such as Rodin – could deviate so creatively from it.

Architecture, rather than painting or sculpture, was first to lead the field in shedding the straitjacket of respectful conformism to outmoded conventions. The inbuilt necessity of architecture to provide solutions to the functional and aesthetic questions of living in the real world, rather than in the art gallery, partly accounts for this. The practical challenge of social problem solving which architecture presents has attracted Paolozzi at various stages of his career, particularly in recent years when he has been occupied by major public art schemes involving building and town planning both in Britain and abroad. Architects of Paolozzi's generation,

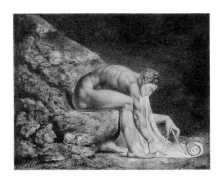

William Blake, *Newton*, 1795. Tate Gallery, London.

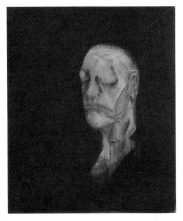

Francis Bacon, *William Blake*, 1955. Tate Gallery, London.

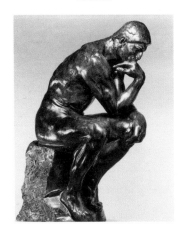

Auguste Rodin, *The Thinker*, 1880. Bronze. Burrell Collection, Glasgow.

such as James Stirling, who has long been an owner of the artist's *As is When* screenprints, would probably not demur at the suggestion that Paolozzi's art has helped to inject a little colour and excitement onto the grey skyline of post-war European architecture. And Paolozzi's fellow-Italian, Richard Rogers, whose architecture so imaginatively marries artistic invention with modern engineering science in a manner that appeals to him, has described Paolozzi's 'forceful, technological poetry' as an 'inspiration', ever since as a twenty-three-year-old student at the Architectural Association he saw the *This is Tomorrow* exhibition at the Whitechapel Art Gallery.[15]

The portrait of Richard Rogers began with William Blake's 1795 colour print of *Newton*. It is an image which Paolozzi has held in his mind, probably since the 1940s, when Blake was regularly represented as a unique British artist under Sir John Rothenstein's Directorship of the Tate Gallery. In the mid-1950s Francis Bacon painted a series of five portraits after Blake's life mask in the National Portrait Gallery. They provide an interesting point of cross reference because they directly precede the portraits of screaming popes after Velazquez in which Bacon explored the aural and painterly expressiveness of the mouth, subject matter not unreminiscent of Paolozzi's portrait sculpture. Paolozzi is a great admirer of Blake, and in particular the idiosyncratic treatment of classicism represented by his version of the Laocoon, which in its printed form of 1820 is circumscribed by Blake's artistic credo, equating artistic expression with religion. Blake's belief in the primacy of Poetic Genius, and the ability of the senses, principally the eye, to see through and beyond materialism to an eternal truth of which the world is only a symbol, is a conceit which might amuse Paolozzi as an allegory for a modern architect, especially a frequently misinterpreted one. In Blake's depiction, Newton represents reason, one stage above the realm of the senses. He stresses Newton's materialism by showing him, head down, inscribing the earth. However, it has also been pointed out that for Blake, Newton contributed towards Man's redemption, by giving a tangible form to error; and in Blake's *Europe* Newton blows the trumpet that leads to the French Revolution.[16] The forward leaning pose, characteristic of rigorous concentration and energy held in reserve, is also suggestive of Rodin's *Thinker*, perhaps the best known of all sculptural metaphors for artistic creation. In Rodin's time, Blake's original meaning, embodied by its neo-classical constraint, would have been lost. The image's power ultimately derives from its poetic ambiguity. This does not prevent, it rather encourages the artist, to search for another solution, by inventing a new form based on the original statement. For this purpose Paolozzi explored the image by making relief sculpture after reproductions of the original colour print by Blake. He then visualised the form in three dimensions. From this two versions resulted. One, modelled in the expressive asymmetric manner of Canova's

terracotta sketches, emphasised the artistic, creative tensions of the sitter; it is essentially a romantic paraphrase of the subject. A second alternative, on which Paolozzi finally settled, emphasises the symmetrical discipline of neo-classical form and is reminiscent of Flaxman. The choice of the 'neo-classical' solution probably meant that he could be freer to invent the rest of the portrait than he would have been had he chosen the more personalised 'romantic' one. He had been developing the portrait head of Rogers simultaneously with the body, so the notional idea of how the two would come together, as well as the rest of the invention, became clearer the longer he progressed with the work. The head underwent a development similar to that of the body; that is to say, a continuing dialogue between nature and art. It began with a series of naturalistic busts which concluded with a severe neo-classical portrait reminiscent of a Roman emperor. After a number of drawings were made after the plaster busts, the final head emerged from a combined distillation of the preceding work.

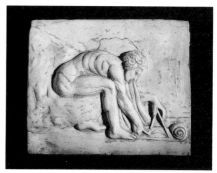

Eduardo Paolozzi, *Relief after Blake's 'Newton'*, 1988. Plaster.

The amalgamation of different traditions in the Rogers portrait, and the symbols of old and new architecture, recall the spirit of Rodin's symbolist memorial to Puvis de Chavannes, with the artist's portrait on top of a classical column attended by a life-size nude figure and an apple tree coated in plaster.[17] The reference to Doric architecture perhaps contains a hint of autobiography; it derives from a plaster model of Playfair's Parthenon-inspired monument in Edinburgh, where Paolozzi grew up. The Beaux Arts style architecture of the Fine Arts Academy in Munich, where he now has a studio, and where Kandinsky and Klee were once students, is also a constant reminder for him of the enduring contrast between the traditions of a past which once gave rise to an influential artistic expression of the future; as are the neo-classical perspectives of the city of Munich itself which for Paolozzi evoke images of De Chirico. For it was De Chirico who transmitted the classical tradition to the Surrealists. His metaphysical paintings of deserted squares and colonnades, littered with the fragments of antiquity, provide a setting in the imagination for Rodin's later portrait allegories which never found public sites.

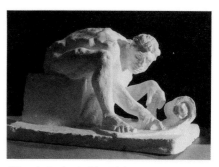

Eduardo Paolozzi, *After Blake's 'Newton'*, 1988. Plaster.

The strange surrealist machine, a descendant of Homer held by the Greek god Hephaestus, exists as a reality in the great *Shield of Achilles* designed in the first decade of the last century by the English sculptor John Flaxman, whose multiple designs were once as influential throughout Europe as they were in Britain.[18] It may be no more than an art-historical coincidence that the reception given to Paolozzi's art in Germany almost exceeds that which it receives at home; and that both sculptors designed for Wedgwood. Certainly Paolozzi has a deep admiration for Flaxman and the neo-classical age, when the forces of artistic invention and mechanical production seem to have been in a more creative equilibrium than they are today. Although art in the late twentieth century has lost the neo-classical

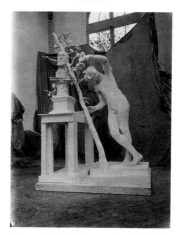

Auguste Rodin, *Monument to Puvis de Chavannes*, from 1901. Plaster. 23.7 x 17.5 cm. Musée Rodin, Paris.

distinction which Fuseli made between invention and creation – 'an idea of pure astonishment, and admissable only when we mention Omnipotence'[19] – a true creative spirit lives on in the images which Paolozzi continues to invent from his imaginative re-ordering of the world. Only the experience and the fears are ours.

NOTES

1. Murray Grigor, *E.P. Sculptor*, a film first shown on Channel 4, December 1987. I am grateful to Murray and Barbara Grigor for providing me with a transcription of their award-winning film on Paolozzi.

2. Eduardo Paolozzi, *Lost Magic Kingdoms and Six Paper Moons*. See especially the essay by Malcolm McLeod, 'Paolozzi and Identity', pp. 13-58.

3. James McNeill Whistler, 'The Red Rag', *The World*, 22 May 1878. Reprinted in J.M. Whistler, *The Gentle Art of Making Enemies*, London, 1892, p. 128.

4. Homer, *The Iliad*, translated by E.V. Rieu, Penguin, Harmondsworth, 1960, pp. 346-53.

5. *Lost Magic Kingdoms*, pp. 6-8.

6. *E.P. Sculptor*.

7. *Eduardo Paolozzi: Recurring Themes*.

8. Eduardo Paolozzi, 'Sculpture and the 20th-Century Condition', *Art and Design*, III, special edition on 'Sculpture Today', December 1987, p. 80.

9. *Lost Magic Kingdoms*, p. 102.

10. Eduardo Paolozzi, 'Collage or a Scenario for a Comedy of Critical Hallucination', in *Eduardo Paolozzi: Collages and Drawings*, exhibition catalogue, Anthony d'Offay, London, 1977.

11. 'Sculpture and the 20th-Century Condition', p. 80.

12. *Henry Fuseli 1741-1825*, exhibition catalogue, Tate Gallery, London, 1975, p. 44. See also, in the same publication, Werner Hofman's essay 'A Captive', pp. 29-37.

13. Albert Elsen, *Rodin Rediscovered*, an exhibition at the National Gallery of Art, Washington D.C., 1981.

14. 'Sculpture and the 20th-Century Condition', p. 80.

15. *Eduardo Paolozzi: Private Vision – Public Art*.

16. Martin Butlin, *The Paintings and Drawings of William Blake*, 2 vols., Yale University Press, New Haven and London, 1981, I, cat. no. 306, pp. 166-67 (II, plate 394).

17. Reproduced in Albert Elsen, *In Rodin's Studio, a photographic record of sculpture in the making*, London, 1980, plate 125.

18. *John Flaxman R.A.*, exhibition catalogue, Royal Academy of Arts, London, 1979. See also, in the same publication, Werner Hofman's essay 'The Death of the Gods', pp. 14-21.

19. *Henri Fuseli 1741-1825*, p. 44.

CATALOGUE

All items are lent by the sculptor unless otherwise stated.
All dimensions are in centimetres.

THE SHELVES
(Illustrated overleaf)

I come from a generation that experienced the last reverberations of that form of teaching scathingly dismissed by more recent generations as Ecole des Beaux Arts. In a white room details from Michelangelo's *David* were secured to upright planks and those details used for copying into clay. The subtleties of convex and concave planes were pointed out by the white smocked teacher, ever in attendance – he himself outlined by calotypes of Degas' drawings. All this was to be swept aside in a senseless stampede towards bizarre modernisation – a new ethos to destroy the creative potential of a thousand souls.

E.P.

1.

TOP SHELF (left to right)

(i) Frog (ii) Hands (iii) Doric columns (from project for Edinburgh) (iv) Wooden mechanism (v) Leg (from *Self-portrait*) (vi) Columns (vii) Cut-up head of Richard Rogers (viii) Small head of *Mr Cruikshank* (ix) Mask of Richard Rogers (x) Chinese lion's head.

MIDDLE SHELF (left to right)

(i) Large figure of Blake's *Newton* (ii) Small columns (iii) Electronic globe (iv) Left foot from *Self-portrait with Strange Machine* (v) Small *Mrs Cruikshank* (vi) Small foot after antique sculpture in the Glyptothek, Munich (vii) Small hand after antique sculpture in Glyptothek (viii) *Portrait of an Actor* after Van Gogh (ix) Leg from *Self-portrait as Hephaestus* (x) Hand from *Self-portrait with Strange Machine* (xi) Two hands after antique sculpture in the Glyptothek (xii) Greek block (xiii) Feet (after photograph of Steve Cram) (xiv) Small self-portrait head (xv) Elements held between hands of *Self-portrait*.

BOTTOM SHELF

(i) Greek block (ii) Hands (iii) Plastic motif (iv) Large relief after Blake's *Newton* (v) Hexagonal elements (vi) Motif for 'Lost Magic Kingdoms' (vii) *Self-portrait* (viii) Greek blocks (ix) Small figure of Blake's *Newton* (x) Broken columns (xi) Left hand from *Self-portrait* (xii) Hands (after Greek sculpture) (xiii) Broken columns (xiv) Hands (xv) Foot (xvi) Small electronic ball (xvii) Hands (xviii) Greek blocks (xix) Small wooden element.

NB: The placing of the objects may differ from the order outlined here.

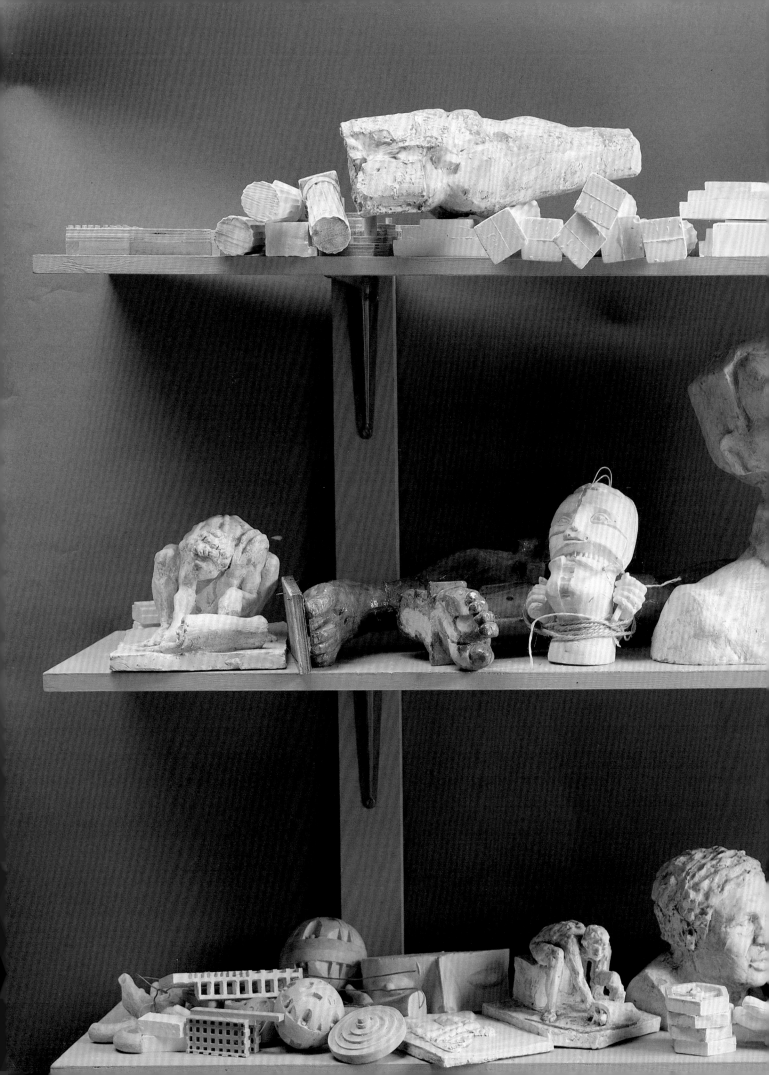

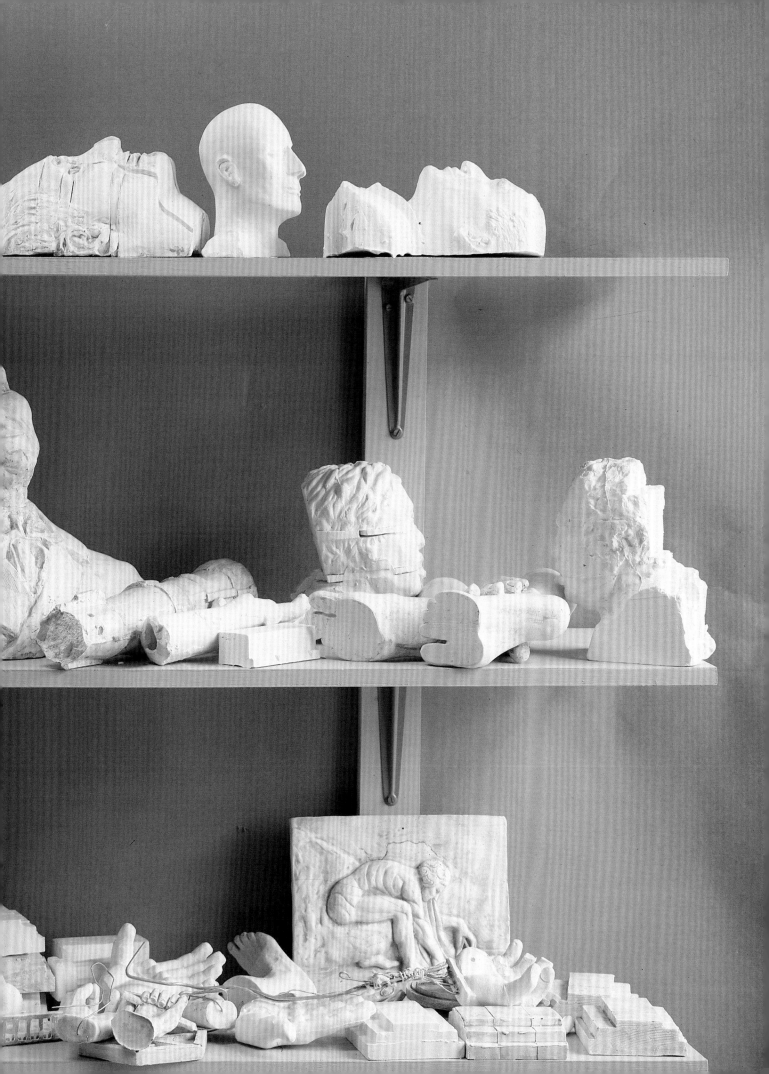

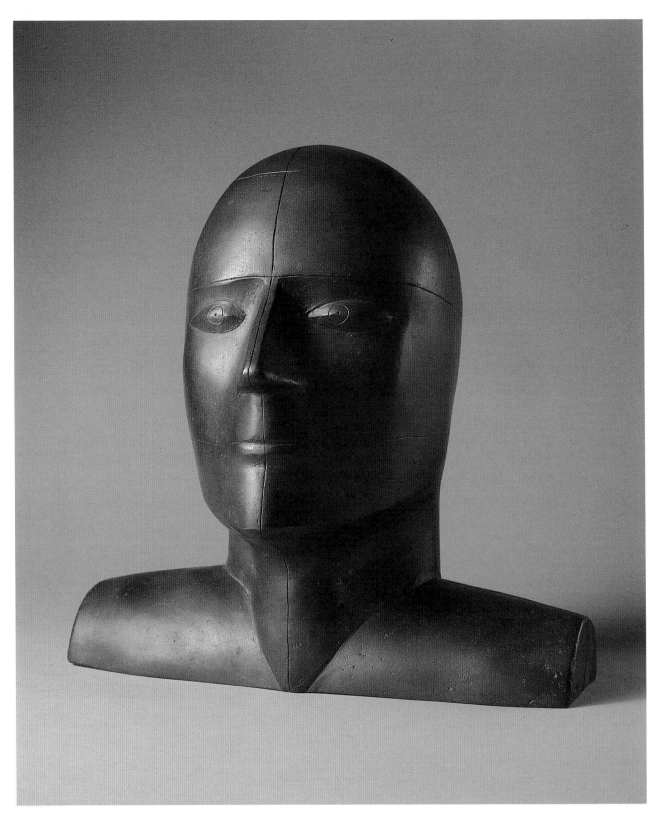

2. Mr Cruikshank 1950

HEADS

2. *Mr Cruikshank* 1950
 Bronze (edition of 9)
 28 x 28 x 20
 Signed: *E. Paolozzi/1950*

3. *Portrait of an Actor (for Luis Buñuel)* 1984
 Plaster (unique)
 35 x 27.5 x 19.5

4. *Electric Bishop* 1984
 Painted plaster and rope (unique)
 40 x 31 x 22.5

5. *The Critic* 1984
 Bronze (unique)
 36.5 x 15.5 x 29
 Signed: *E. Paolozzi 1/2 '84*

6. *Kardinal Syn* 1984
 Plaster and string (unique)
 45.5 x 45.5 x 29

7. *Man in a Green Sweater* 1985
 Painted plaster and string (unique)
 41 x 44 x 24

8. *Count Basie* 1987
 Bronze (edition of 2)
 39.4 x 27.9 x 21

WORKS ON PAPER

9. *Head of Zeus* 1946
 Collage on paper
 24 x 17.5
 Signed (below): *E. Paolozzi 1946*

10. *Self-portrait* 1947
 Collage on paper
 33 x 25.5
 Signed (b.r.): *E. Paolozzi 1947*

11. *Medicine is for people, not for profits* 1952
 Collage on paper
 19.6 x 21.2

12. *Green Dolphin Street* 1952
 Collage on paper
 31.7 x 25.5

13. *Two Women* 1984
 Etching
 16 x 23.2
 Artist's proof

14. *Three Heads* 1984
 Etching
 16.8 x 29.4
 Artist's proof

15. *Heads of Heroes* 1987
 Postcard proof sheet
 31.5 x 46.4

16. *Heads of Heroes* 1987
 Postcard proof sheet
 31.5 x 46.4

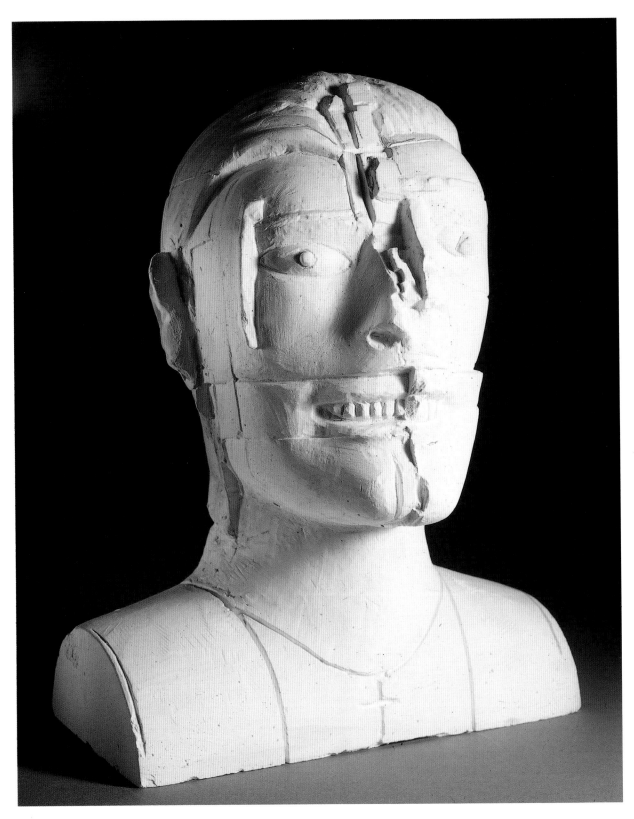

3. Portrait of an Actor (for Luis Buñuel) 1984

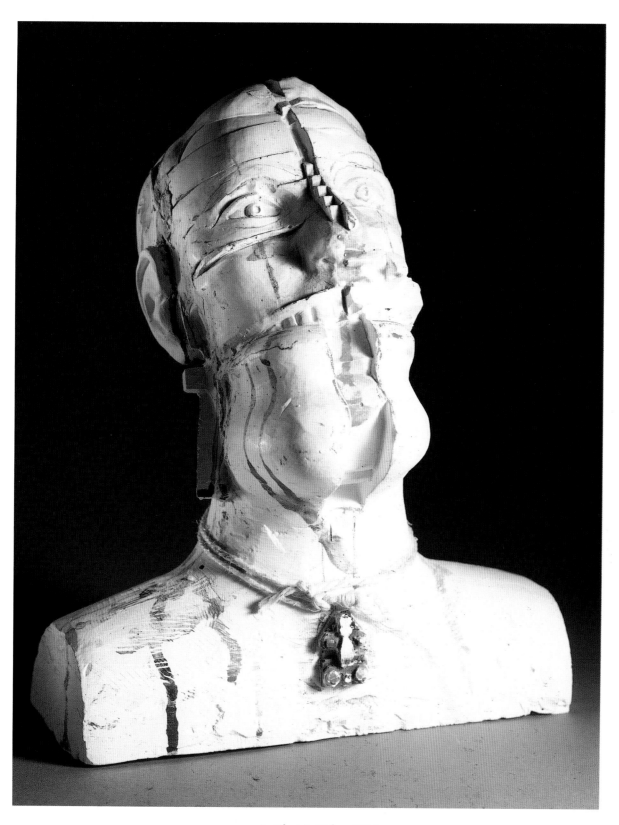

4. *Electric Bishop 1984*

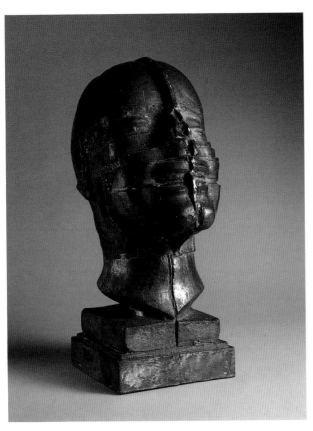

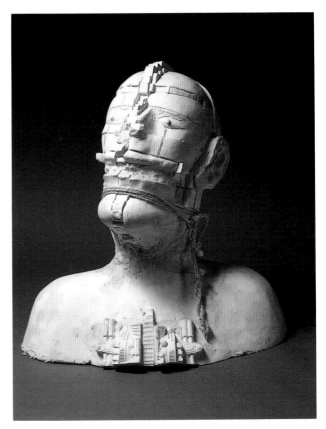

5. The Critic 1984 *6. Kardinal Syn 1984*

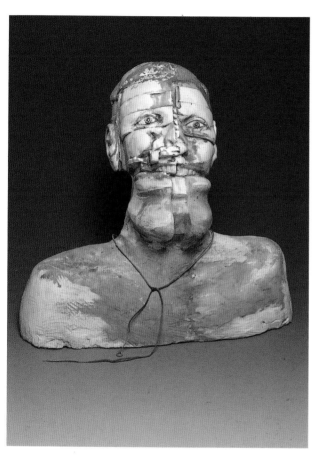

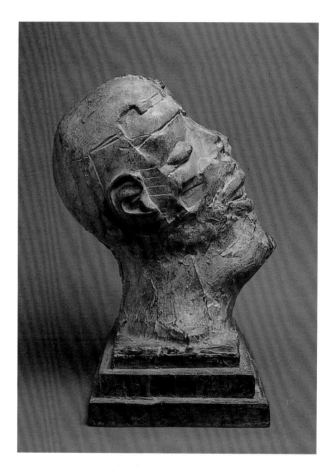

7. *Man in a Green Sweater 1985*

8. *Count Basie 1987*

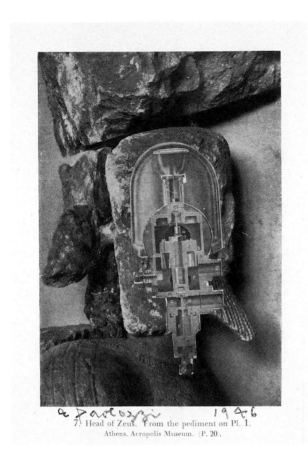

9. *Head of Zeus 1946*

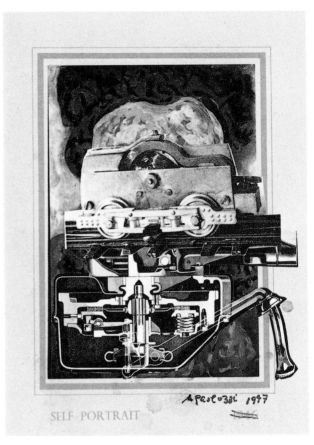

10. *Self-portrait 1947*

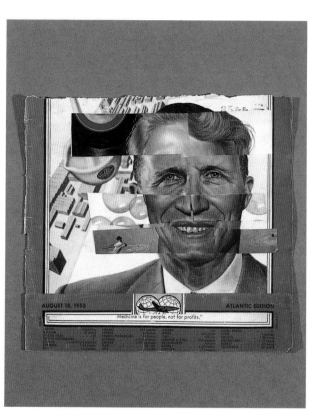

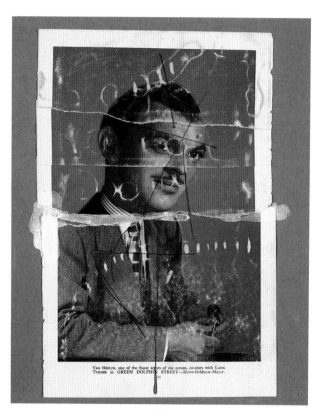

11. *Medicine is for people, not for profits 1952*

12. *Green Dolphin Street 1952*

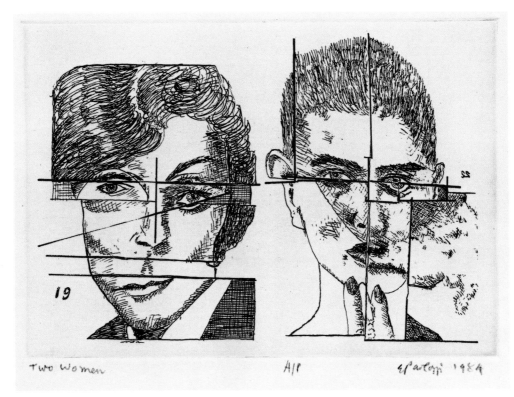

13. Two Women 1984

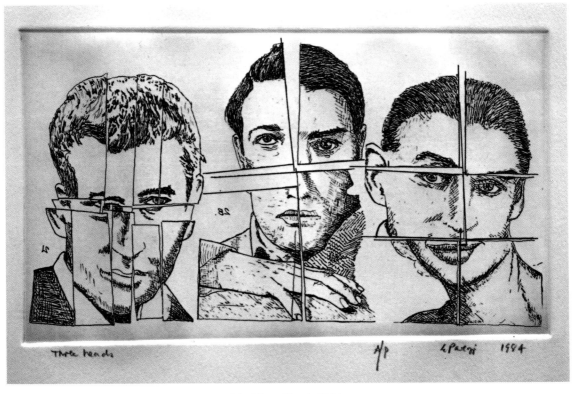

14. Three Heads 1984

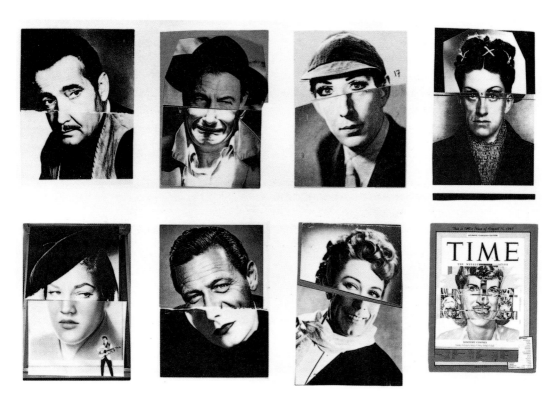

15. *Heads of Heroes 1987*

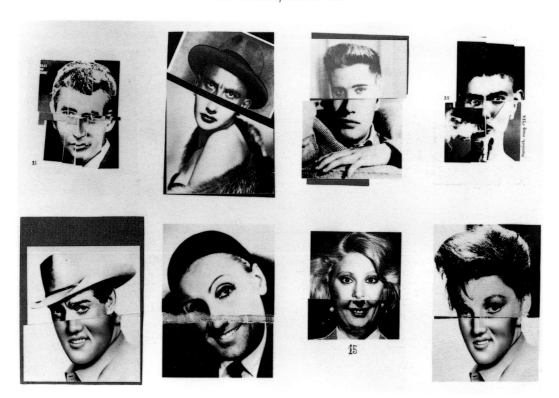

16. *Heads of Heroes 1987*

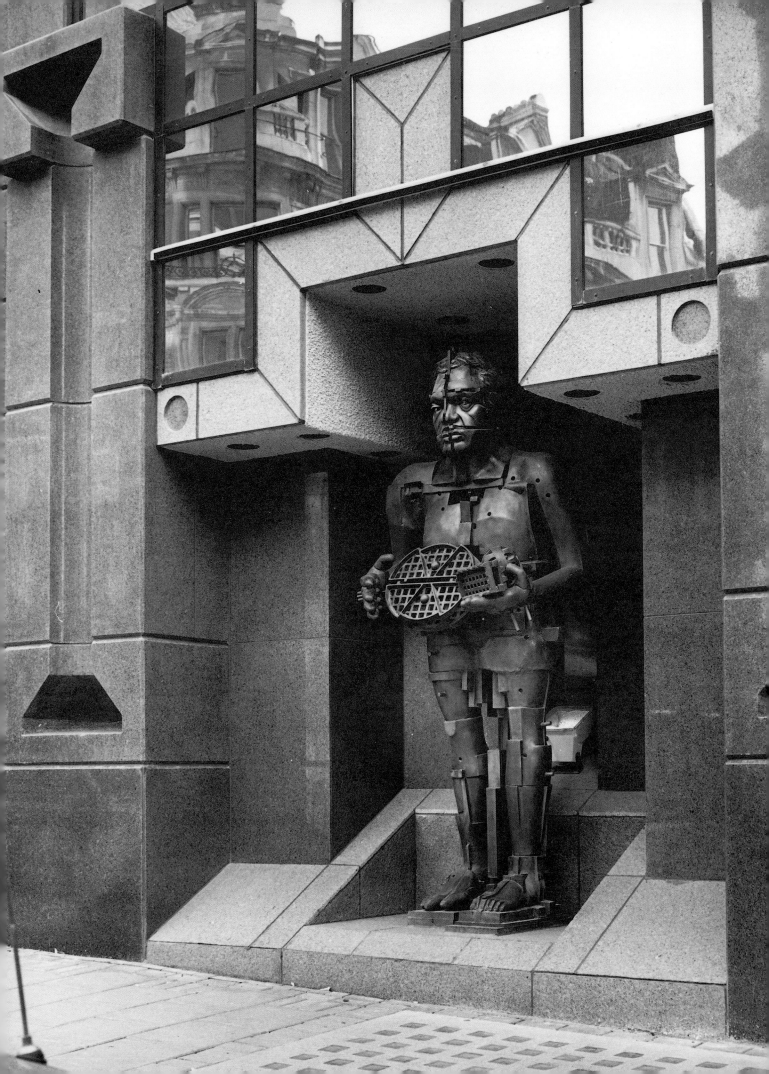

SELF-PORTRAITS

THE MODERN CONDITION AND THE SELF-PORTRAIT

What might describe the modern condition is that in creating a self-portrait today's artist (unlike Rembrandt or Van Gogh) will not stare at himself in a mirror but will try to capture his likeness by other means. The approach of a sculptor – beginning with blocks of clay, then translating that into other materials – either disguises the superficial facts of the self-portrait or, if the artist is lucky, reveals new personal insights. In my interpretation, the torso for example is an amalgam of shapes but the tension between the head and the limbs should guarantee that these inventions read either as an engine block or as flesh.

E.P.

17. *The Artist as Hephaestus* 1987
 Plaster and polystyrene
 264 x 107 x 76.5

 The original model for the bronze commissioned by London and Bristol Developments for their new building at 34-36 High Holborn, London.

18. *Portrait of the Artist as Vulcan* 1987
 Bronze (edition of 3)
 84.5 (h.)
 Michael Rothenstein

19. *Self-portrait with Strange Machine* 1987
 Bronze (edition of 3)
 85.1 x 40.6 x 29.2
 Signed: *E.PAOL/LOZZI/VULCAN/1987*
 National Portrait Gallery

20. *Study for Self-Portrait* 1988
 Bronze (unique)
 82.5 x 19.7 x 28.5

21. *Head of Hephaestus* 1987
 Bronze (unique)
 61 x 39.4 x 39.4
 Peter Davidson

WORKS ON PAPER

22. *The Artist as Hephaestus* 1987
 Etching (edition of 100)
 20.5 x 11.5

 Commissioned by London and Bristol Developments for the unveiling of the bronze sculpture.
 National Portrait Gallery

23. Study for the head of Hephaestus 1987
 Pencil and ink on tracing paper
 41.8 x 29.5

24. Study for the legs of Hephaestus 1987
 Pencil and ink on tracing paper
 41.8 x 29.5

25. Study for the hands of Hephaestus 1987
 Pencil and ink on tracing paper
 41.8 x 29.5

26. Study for the torso of Hephaestus 1987
 Pencil and ink on tracing paper
 41.8 x 29.5

The Artist as Hephaestus at 34-36 High Holborn, London.

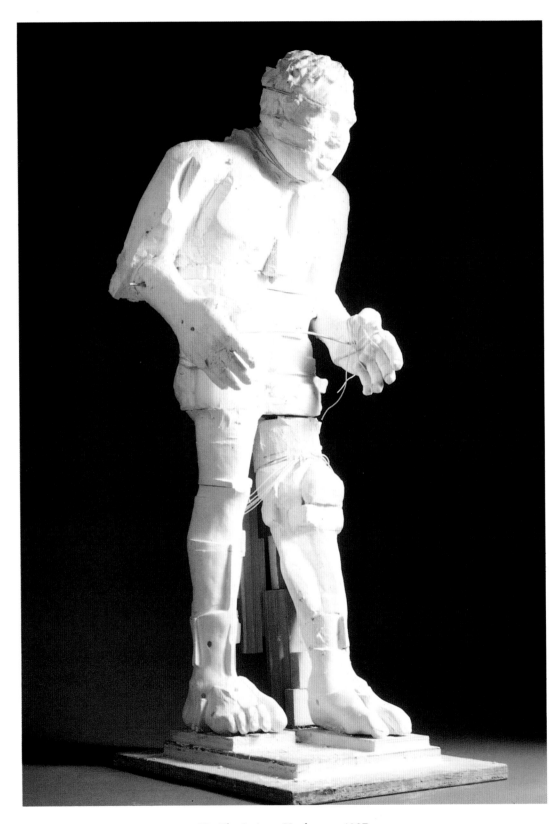

17. The Artist as Hephaestus 1987

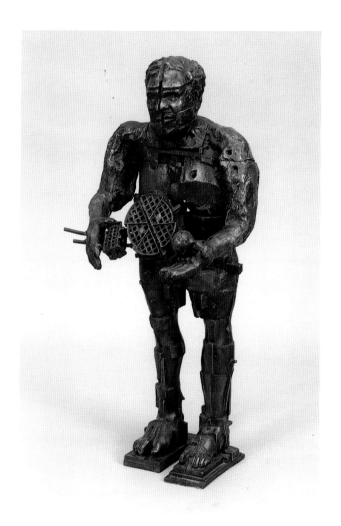

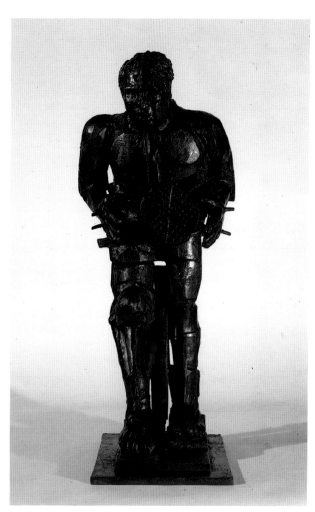

18. *Portrait of the Artist as Vulcan 1987*

19. *Self-portrait with Strange Machine 1987*

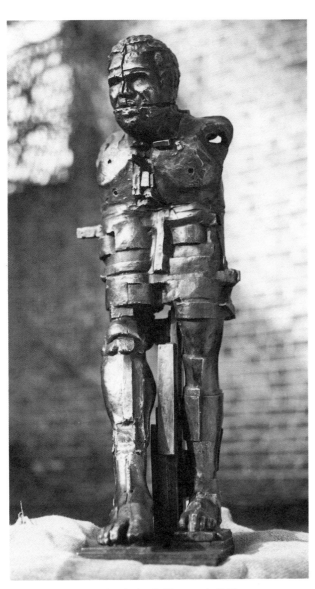

20. *Study for Self-portrait 1988*

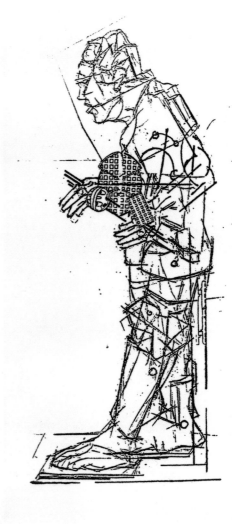

56/100

Eduardo Paolozzi '87

22. *The Artist as Hephaestus 1987*

21. *Head of Hephaestus 1987*

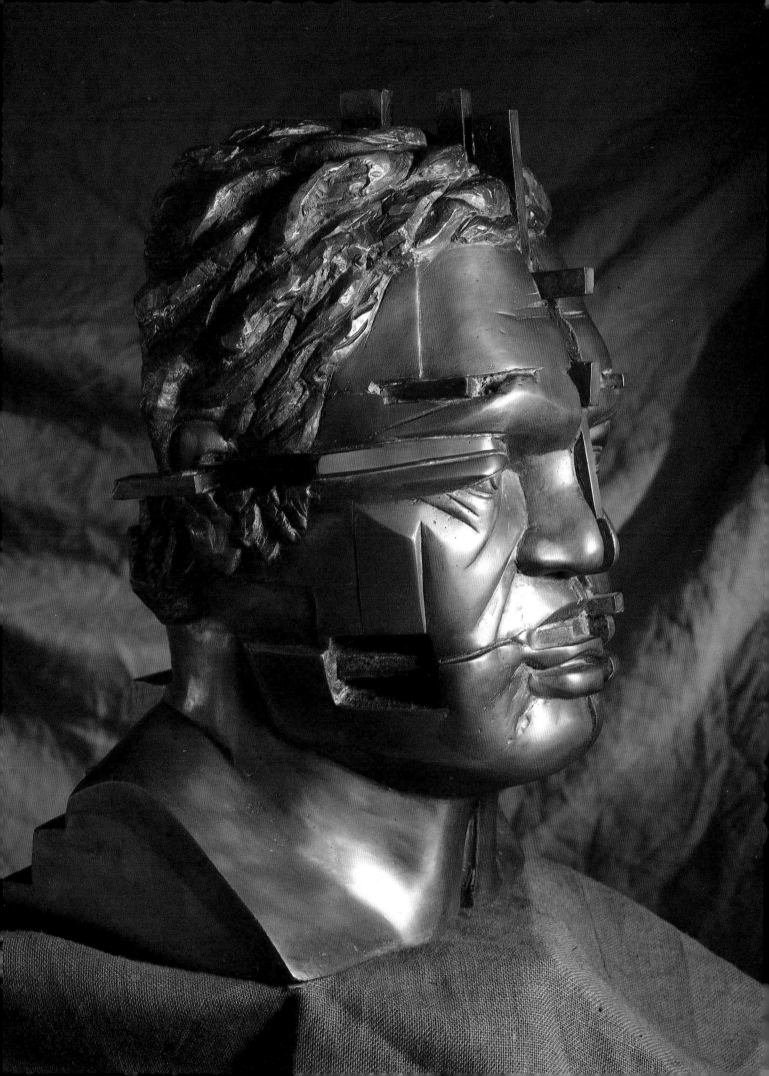

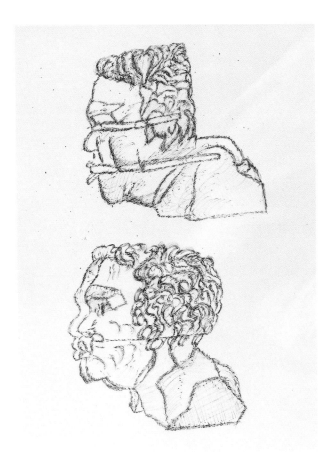

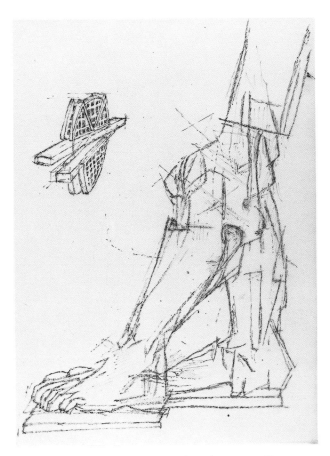

23. *Study for the head of Hephaestus 1987*

24. *Study for the legs of Hephaestus 1987*

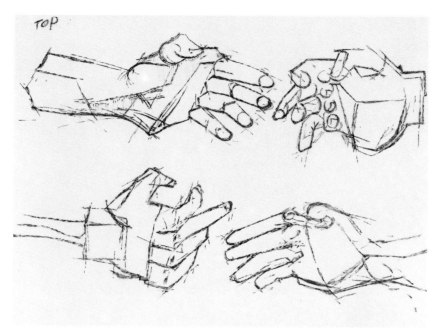

25. Study for the hands of Hephaestus 1987

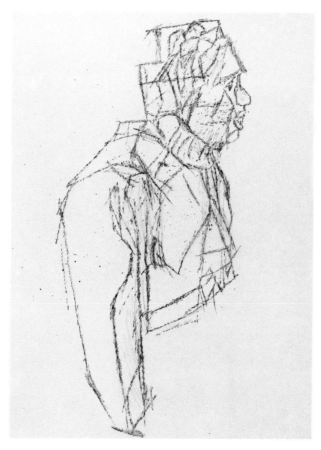

26. Study for the torso of Hephaestus 1987

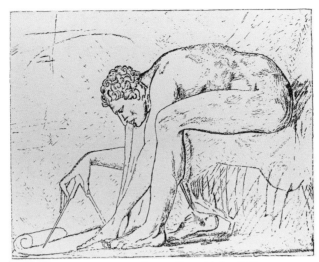

27. Newton *after William Blake 1988*

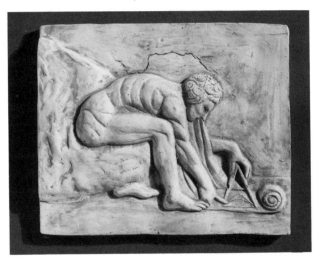

Relief after Blake's Newton

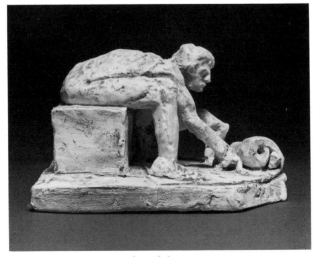

Figure after Blake's Newton

PORTRAITS OF RICHARD ROGERS

It is an advantage to expand a concept beginning from a known position — to exploit the spectator's vision drenched with its implants, notions and preconceptions. Add to this the widely accepted conventions of modern sculpture. Destroy the surface in order to trace a new plane. Juggle with proportions a little and recast the working plasters to keep making minute changes which finally describe that bizarre harmony that suggests the sitter.

<div align="right">E.P.</div>

27. *Newton* after William Blake 1988
 Ink
 25 x 31.5

28. Study for Portrait of Richard Rogers (unsmiling) 1988
 Plaster
 51 (h.)

29. Study for Portrait of Richard Rogers (smiling) 1988
 Plaster
 51 (h.)

30. Three heads of Richard Rogers 1988
 Pencil and ink on tracing paper
 29.5 x 41.8

31. Three heads of Richard Rogers 1988
 Pencil and ink on tracing paper
 29.5 x 41.8

32. Head of Richard Rogers 1988
 Pencil and ink on tracing paper
 41.8 x 29.5

33. Head of Richard Rogers 1988
 Pencil and ink on tracing paper
 41.8 x 29.5

34. Study for bust of Richard Rogers 1988
 Pencil and ink on tracing paper
 41.8 x 29.5

35. Head of Richard Rogers 1988
 Pencil and ink on tracing paper
 41.8 x 29.5

36. Profile of Richard Rogers 1988
 Pencil and ink on tracing paper
 41.8 x 29.5

37. Study for bust of Richard Rogers 1988
 Pencil and ink on tracing paper
 41.8 x 29.5

38. Study for bust of Richard Rogers 1988
 Pencil and ink on tracing paper
 41.8 x 29.5

39. Portrait of Richard Rogers 1988
 Bronze

40. Portrait of Richard Rogers 1988
 Bronze

41. Richard Rogers as Newton 1988
 Bronze

A portrait of the architect, Richard Rogers, was commissioned by the Trustees of the National Portrait Gallery.
Nos. 39-41 were not yet cast at the time of writing; one of these will be accepted for the National Portrait Gallery collection.

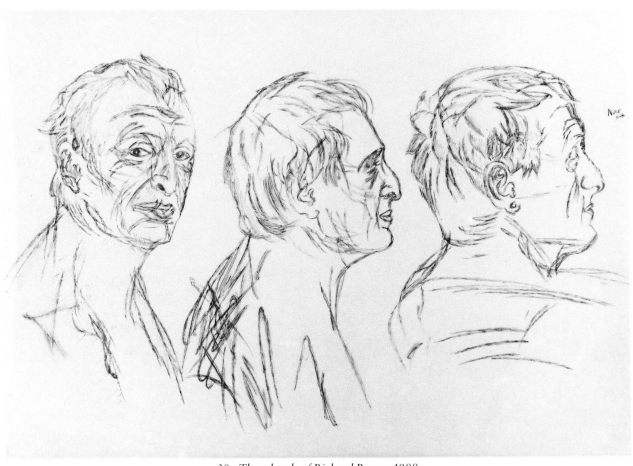

30. Three heads of Richard Rogers 1988

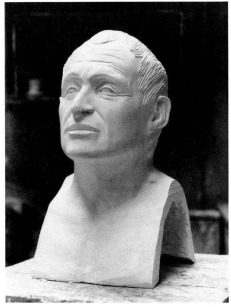

28. Study for Portrait of Richard Rogers (unsmiling) 1988

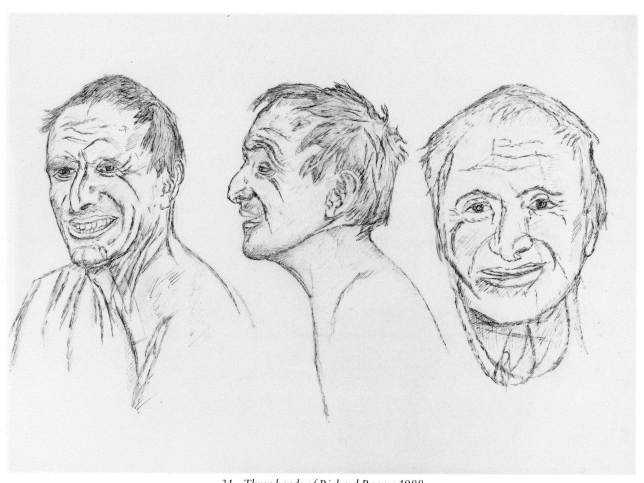

31. Three heads of Richard Rogers 1988

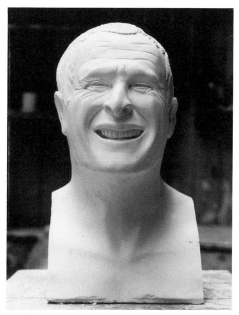

29. Study for Portrait of Richard Rogers (smiling) 1988

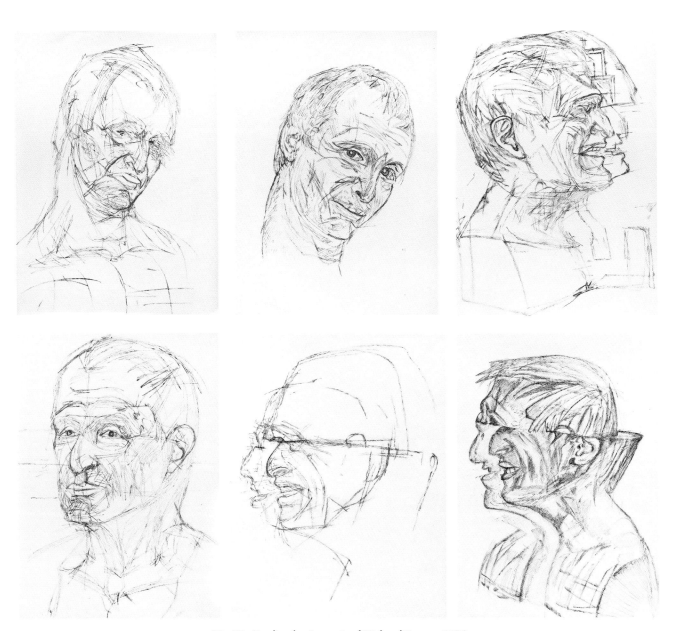

32.-37. *Studies for Portrait of Richard Rogers 1988*

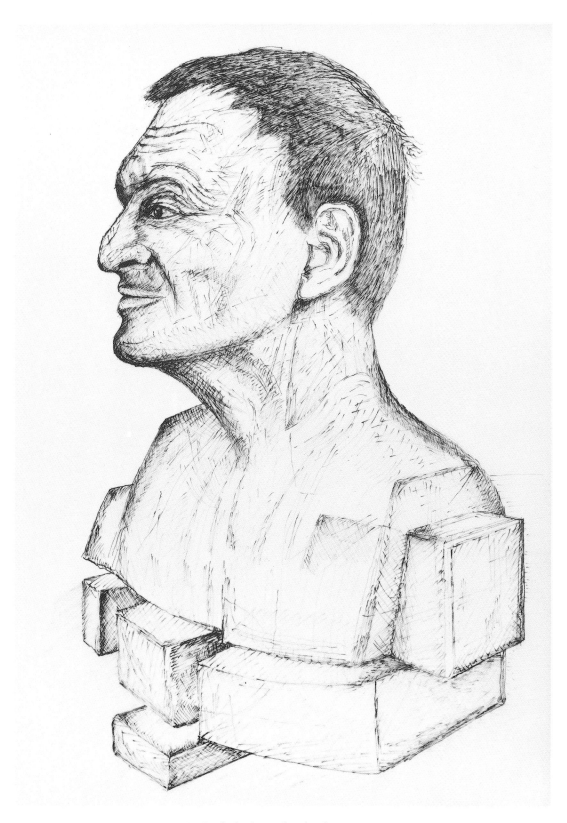

38. Study for bust of Richard Rogers 1988

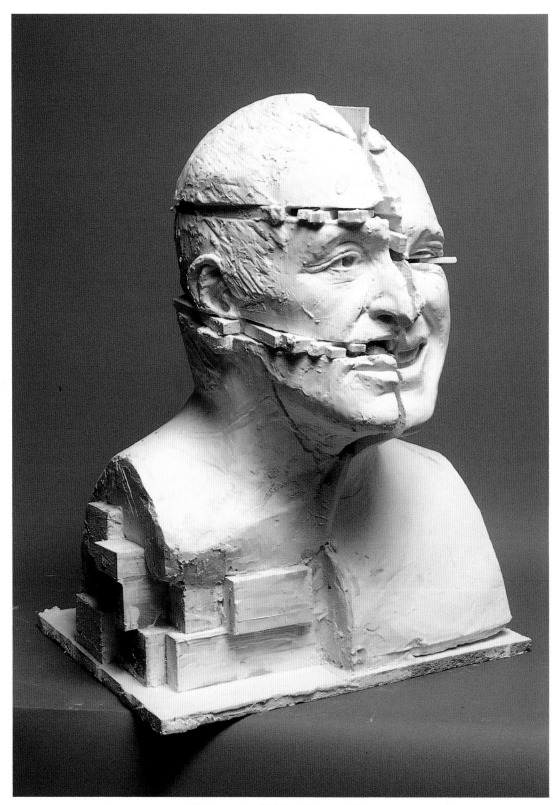

39. Portrait of Richard Rogers 1988
(Plaster)

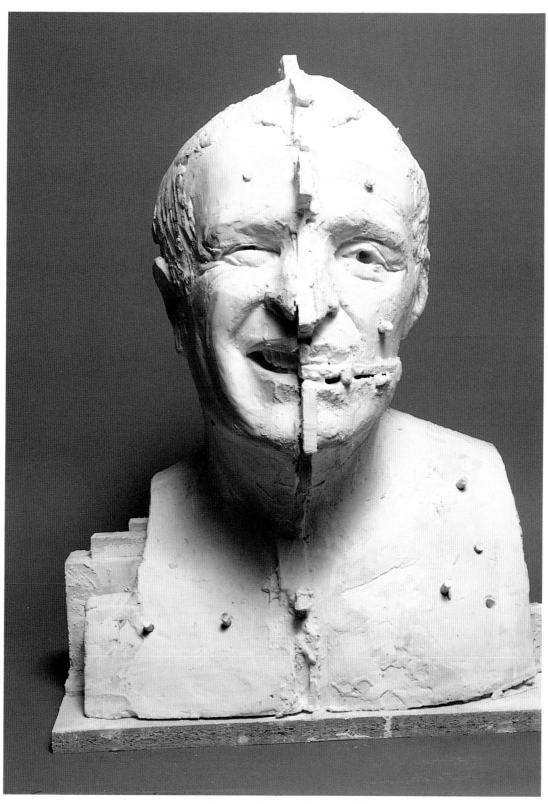

40. Portrait of Richard Rogers 1988
(Plaster)

EDUARDO LUIGI PAOLOZZI

born 7 March 1924 in Leith, Scotland
1943 studied at Edinburgh College of Art
1944-47 studied at Slade School of Art, London
1947-50 worked in Paris
1955-58 taught sculpture at St. Martin's School of Art, London
1968 London lecturer in Ceramics at Royal College of
to present Art, London
1977-81 Professor of Ceramics at Fachhochschule, Cologne
1981 Professor of Sculpture, Akademie der Bildenden
to present Künste, Munich

MAJOR AWARDS

1953 British Critics Prize
1960 David E. Bright Foundation award for best sculptor under 45 at 30th Venice Biennale
1967 Purchase Prize at International Sculpture Exhibition at Solomon R. Guggenheim Museum, New York
 First prize for Sculpture at Carnegie International Exhibition for Contemporary Painting and Sculpture, Pittsburgh
1975 Saltire Society award for ceiling panels and window tapestries at Cleish Castle, Scotland
1978 Commission award in closed competition of sculpture for European Patent Office, Munich
1980 First Prize in closed competition for development of Rhinegarten, Cologne
1981 Saltire Society award for cast aluminium doors to Hunterian Gallery, University of Glasgow
1983 Grand Prix d'Honneur, 15th International Print Biennale, Ljubljana, Yugoslavia

SELECTED ONE MAN EXHIBITIONS

1947 *Drawings and Sculptures by Eduardo Paolozzi*, The Mayor Gallery, London
1960 British Pavilion, 30th Venice Biennale, retrospective, travelling to Belgrade, Paris, Bochem, Brussels, Oslo, Denmark, Baden-Baden, Tubingen
1964 *Eduardo Paolozzi: Sculpture*, The Museum of Modern Art, New York
1967 *Eduardo Paolozzi*, Rijksmuseum, Kröller-Muller, Otterlo

1968 *Eduardo Paolozzi: Serigrafieën*, Stedelijk Museum, Amsterdam
 Eduardo Paolozzi: Plastik und Graphik, Städtische Kunsthalle, Düsseldorf
1971 *Eduardo Paolozzi*, Tate Gallery, London
1974 *Eduardo Paolozzi*, Kestner-Gesellschaft, Hanover
1975 *Eduardo Paolozzi, Skulpturen, Zeichnungen, Collagen, Druckgrafik*, Staatliche Museum Preussischer Kulturbesitz, Nationalgalerie und Kupferstichkabinett, Berlin
1977 *Eduardo Paolozzi, Collages and Drawings*, Anthony d'Offay, London
 The Complete Prints of Eduardo Paolozzi – Prints, Drawings, Collages 1944-77. Victoria and Albert Museum, London
1979 *The Development of the Idea*, Glasgow, Glasgow League of Artists, touring to Crawford Centre, University of St Andrews and Talbot Rice Arts Centre, University of Edinburgh
 Eduardo Paolozzi, Work in Progress, Kölnischer Kunstverein, Cologne
1984 *Eduardo Paolozzi: Private Vision – Public Art*, Architectural Association, London
 Eduardo Paolozzi: Recurring Themes, Royal Scottish Academy, Edinburgh and touring
 Eduardo Paolozzi, Städtische Galerie im Lenbachhaus, Munich
1985 *Eduardo Paolozzi*, Museum Ludwig, Cologne
 Eduardo Paolozzi, Ivan Doughterty Gallery, Paddington, Australia and tour
 Eduardo Paolozzi: Recurring Themes, ELAC, France
 Lost Magic Kingdoms and Six Paper Moons (created by Eduardo Paolozzi), Museum of Mankind, London, and touring in 1988 to Glynn Vivien Art Gallery, Swansea, Birmingham City Art Gallery, Graves Art Gallery, Sheffield, York City Art Gallery, Bolton Museum and Art Gallery and in 1989 to Leeds City Art Gallery
 Eduardo Paolozzi: Recurring Themes, Crawford Municipal Art Centre, Cork
1986 *Eduardo Paolozzi Underground*, Royal Academy, London
 Eduardo Paolozzi: Köpfe, Skulpturen-Museum Glaskasten, Marl
1987 *Eduardo Paolozzi: Sculptures from a Garden*, Serpentine Gallery, London
1988 *Paolozzi Portraits*, National Portrait Gallery, London

SELECTED GROUP EXHIBITIONS

1952 26th Biennale, Venice
1953 *Parallel of Life and Art*, Institute of Contemporary Art, London
1956 *This is Tomorrow*, Whitechapel Art Gallery, London
1957 *New Trends in British Art*, New York Art Foundation, Rome
 Ten Young Sculptors, IV Bienal de São Paolo, São Paolo
1959 *Documenta II*, Kassel
 New Images of Man, Museum of Modern Art, New York
1962 *British Art Today*, touring exhibition
1963 7th International Art Exhibition, British Section, Tokyo
1964 *Documenta III*, Kassel
 Neue Realisten und Pop'Art, Akademie der Künste, West Berlin
1967 *Sculpture from Twenty Nations*, Solomon R. Guggenheim Museum, New York, touring to Toronto, Ottawa and Montreal
1968 *L'Art Vivant 1965-8*, Fondation Maeght, Saint Paul de Vence
 Britische Kunst Heute, Kunstverein, Hamburg
 Documenta IV, Kassel
1969 *Pop Art Redefined*, Hayward Gallery, London
1970 Osaka Expo '70
1972 *British Sculptors*, Royal Academy of Arts, London
1976 *Arte Inglese Oggi*, Palazzo Reale, Milan
1977 *Hayward Annual*, Hayward Gallery, London
1980 *Reliefs*, Westfälischer Kunstverein, Münster, and tour to Kunsthaus, Zurich
1981 *20th Century British Sculpture*, Whitechapel Art Gallery, London
 Sculpture for the Blind, Tate Gallery, London
 Westkunst, Rheinhallen, Cologne
1982 *Innovations in Contemporary Printmaking*, Ashmolean Museum, Oxford
1983 *English Painters 1900-82*, Museo Municipal, Madrid
 Drawing in Air, Sunderland Art Centre and tour to Edinburgh and Swansea (opened by Eduardo Paolozzi in Swansea)
1984 *Artistic Collaboration*, Hirshhorn Museum, Washington
 The Automobile and Culture, Detroit Institute of Arts
 Between Object and Image: Sculpture from Britain, Palacio de Velazquez, Madrid, and tour to Barcelona
 Contrariwise, Glynn Vivian Gallery, Swansea
1987 *British Art in the Twentieth Century*, Royal Academy of Arts, London

SOME RECENT COMMISSIONS

1977 'Hommage a Anton Bruckner' cast iron sculpture for Forum Metal, Linz, Austria
1978 'Camera' cast iron sculpture for European Patent Office, Munich
1979 Bronze relief for private block of flats, Moorweidenstrasse 3, Hamburg
1976-80 Four cast aluminium doors for Hunterian Gallery, University of Glasgow
1980-81 'Piscator' painted cast iron sculpture for Euston Square, London
1979-82 Cooling tower cast iron panels for Rampayne Street complex, London
1985-86 'On This Island' constructed wood relief for Benjamin Britten Lounge in Queen Elizabeth II Conference Centre, London
1980-86 Glass mosaics for Tottenham Court Road underground station, London
 26 element bronze sculpture with water and stone for RhineGarden by Museum Ludwig, Cologne
1985-87 'The Artist as Hephaestus' bronze self-portrait commissioned for 34-36 High Holborn, London

BOOKS ON EDUARDO PAOLOZZI

Lawrence Alloway (in collaboration with Eduardo Paolozzi), *Metallization of a Dream*, Lion and Unicorn Press (Royal College of Art), London, 1963
Diane Kirkpatrick, *Eduardo Paolozzi*, Studio Vista, London, 1970
Winfried Konnertz, *Eduardo Paolozzi*, Dumont Verlag, Cologne, 1984
Michael Middleton, *Eduardo Paolozzi* (Art in Progress Series), edited by Jasia Reichardt, Methuen, London, 1963
Uwe Schneede, *Paolozzi* (Modern Artists Series), Harry N. Abrams Inc., New York, 1970
Robin Spencer, *Eduardo Paolozzi: Recurring Themes*, Trefoil, London, 1984 (catalogue for exhibition at Royal Scottish Academy)

BOOKS BY EDUARDO PAOLOZZI

Metafisikal Translations, Kelpra Studio Ltd. and Eduardo Paolozzi, London, 1962
Kex, edited by Richard Hamilton, printed by Lund Humphries for the William and Norma Copley Foundation, London, 1966
Abba Zaba, edited and printed by Hansjorg Mayer and the students of Watford School of Art, 1970

FILMS BY EDUARDO PAOLOZZI

'The History of Nothing' with Denis Postle, 1960-62
'Mr. Machine', 1971 (animators – Peter Lake and Keith Griffiths)

ADDITIONAL INFORMATION

1968 Commander of the British Empire (C.B.E.)
1979 Royal Academician, London (R.A.)
 Honorary Doctorate from Royal College of Art, London
1980 Honorary Doctor of Literature, University of Glasgow
1981 Honorary Member of Architectural Association, London
1986 Fellow of University College, London
 Her Majesty's Sculptor in Ordinary for Scotland
1987 Honorary Doctor of Letters, Heriot-Watt University, Edinburgh
 Honorary Doctor of Literature, University of London
 Honorary Member, Royal Scottish Academy, Edinburgh
 Ipswich School art department named 'Eduardo Paolozzi Art School'

INDEX OF EXHIBITS